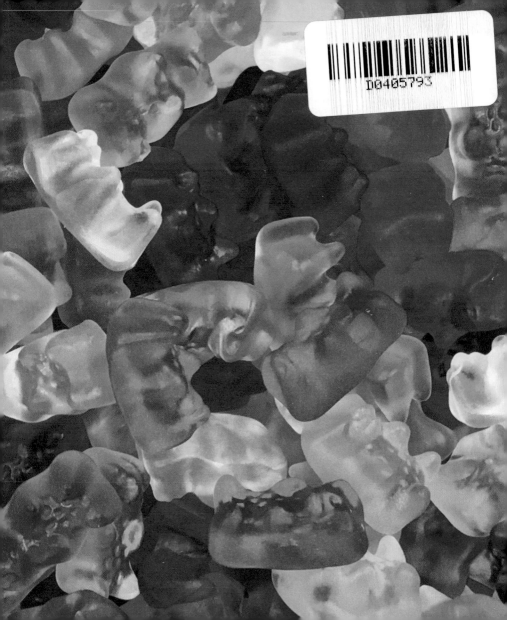

D0405793

Created, published, and distributed by Knock Knock
1635 Electric Ave.
Venice, CA 90291
knockknockstuff.com
Knock Knock is a registered trademark of Knock Knock LLC

© 2017 Dan Golden
All rights reserved
Printed in China

Photographs by Dan Golden
www.dangolden.com

No part of this product may be used or reproduced in any manner whatsoever
without prior written permission from the publisher, except in the case of brief
quotations embodied in critical articles and reviews. For information, address
Knock Knock.

This book is a work of editorial nonfiction meant solely for entertainment
purposes. It is not intended to advocate eating gummy bears, or to dispense
dietary advice. The publisher and anyone associated with the production
of this book do not endorse or share business interests with any candy
manufacturer whatsoever. In no event will Knock Knock be liable to any reader
for any damages, including direct, indirect, incidental, special, consequential,
or punitive damages, arising out of or in connection with the use of the
information contained in this book. So there.

Where specific company, product, and brand names are cited, copyright
and trademarks associated with these names are property of their respective
owners.

ISBN: 978-168349011-1
UPC: 825703-50147-6

10 9 8 7 6 5 4 3 2

The Gummy Bear Book

Dan Golden

KNOCK KNOCK®
VENICE, CALIFORNIA

Hi there.

A couple of years ago I got in the habit of picking up a bag of gummy bears on the way to my studio. Being a candy freak, my sugar cravings would invariably kick in around 11AM, and gummy bears proved to be a tasty treat I could feel relatively good about snacking on throughout the day.

I began to notice that there were actually many different types of gummy bears out there: The classic, waxy version. The softer, generic kind. More exotic varieties, such as sour (my personal favorite) and mini (why even bother?).

As my obsession grew, I even briefly toyed with the idea of opening a gummy bear company myself, where I would make artisanal versions such as jalapeño, truffle, Grand Marnier, etc. (Any interested investors out there?)

In the studio one day, after a prolonged period of staring intently at a gummy bear and contemplating my existence/mortality, the idea for this book popped into my head. What if I could combine two of the things I love most in this world, candy and humor? How could that not be a winning combination?

What you hold in your hands is the result of this revelation. My hope is that you enjoy flipping through this book as much as I enjoyed creating it.

—Dan Golden

p.s. No gummy bears were harmed during the making of this book.

Acrobats

Pillow Talk

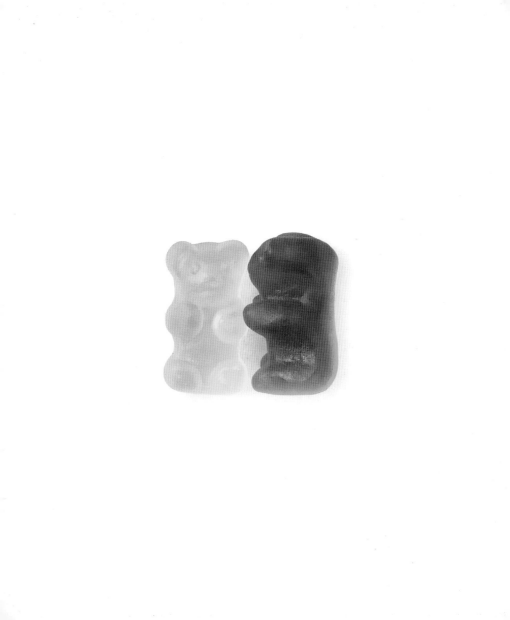

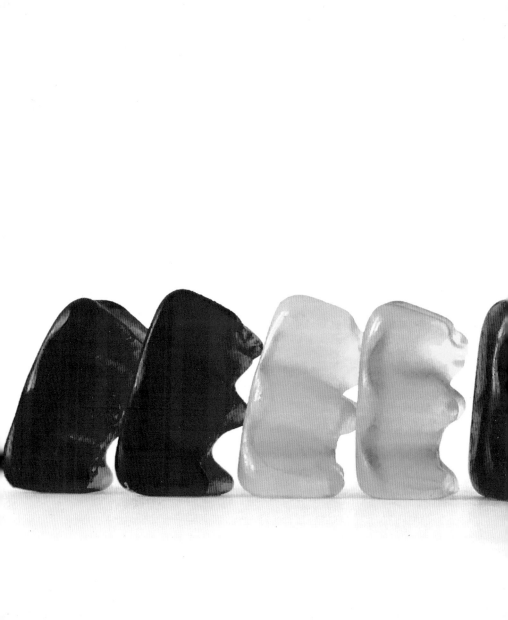

Conga Line

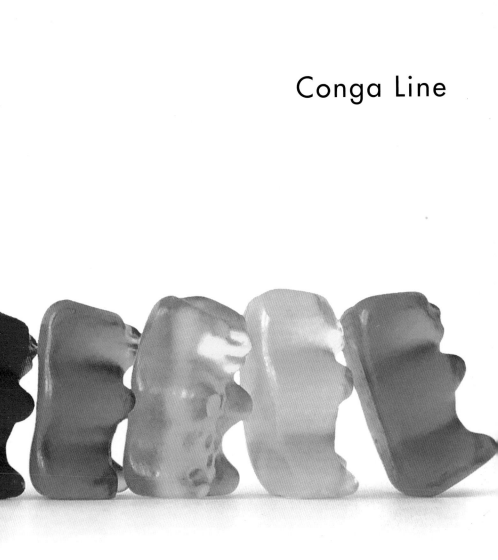

Pep Squad

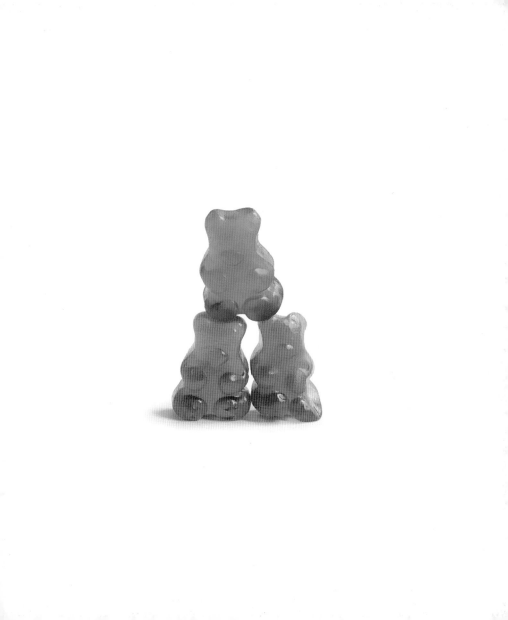

Magic Trick

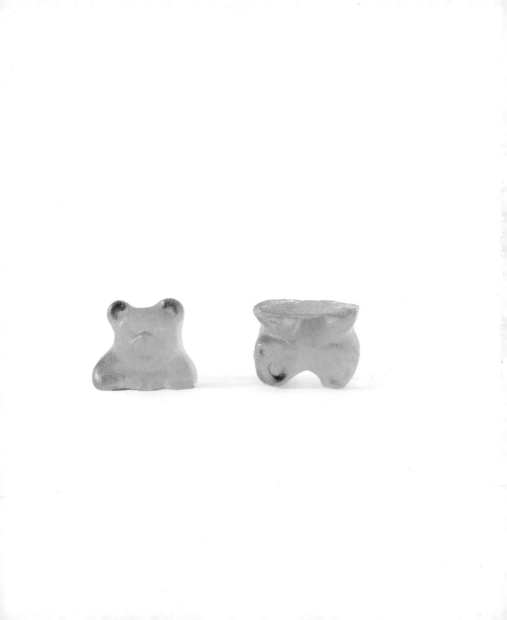

Mosh Pit

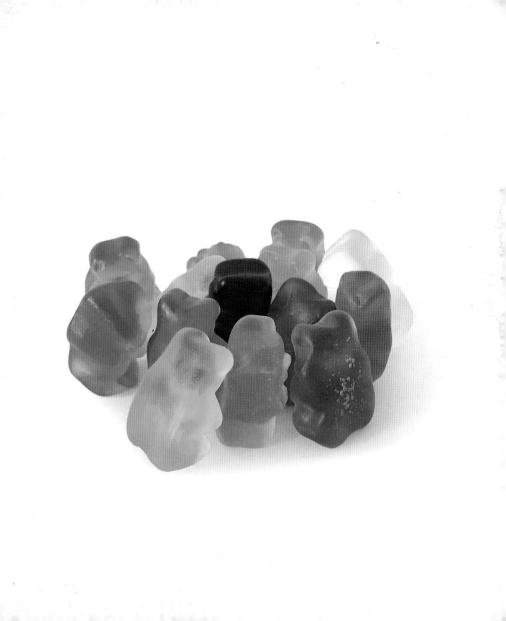

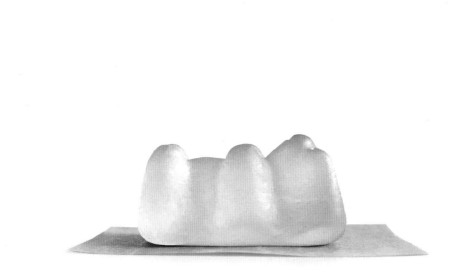

Before

Day at the Beach

After

Ventriloquist

Preppies

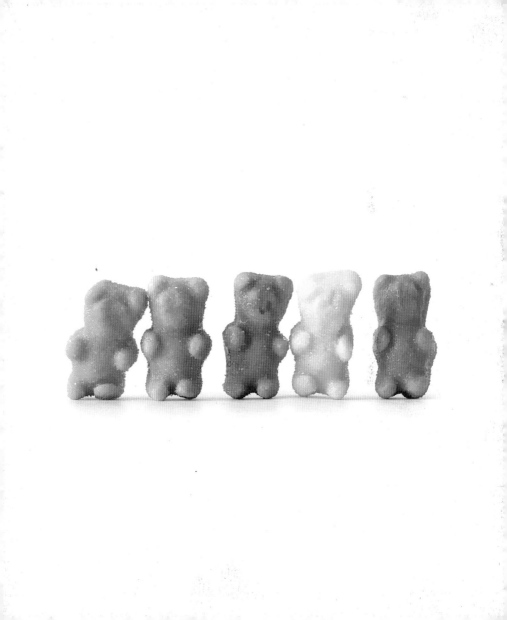

Goths

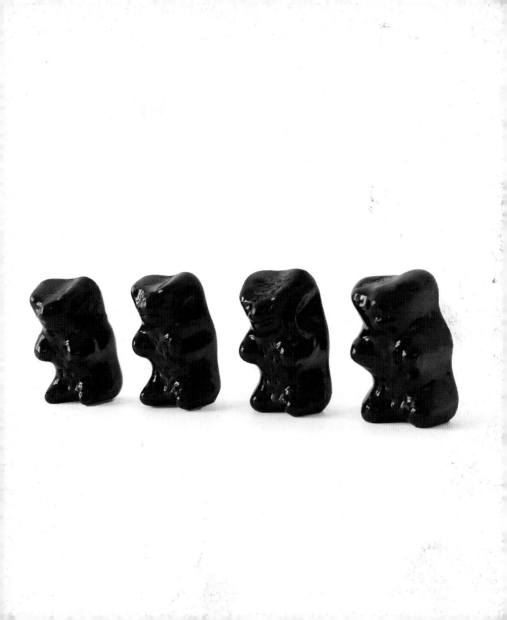

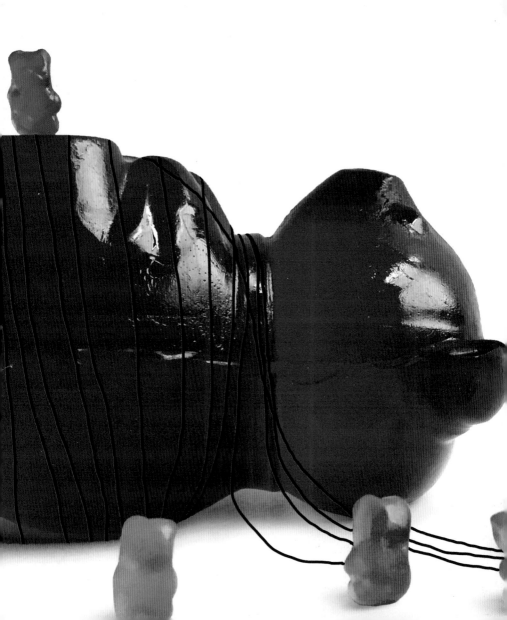

Gulliver's Travels

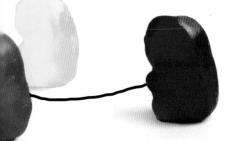

Frankenstein's Monster

Contemporary Art

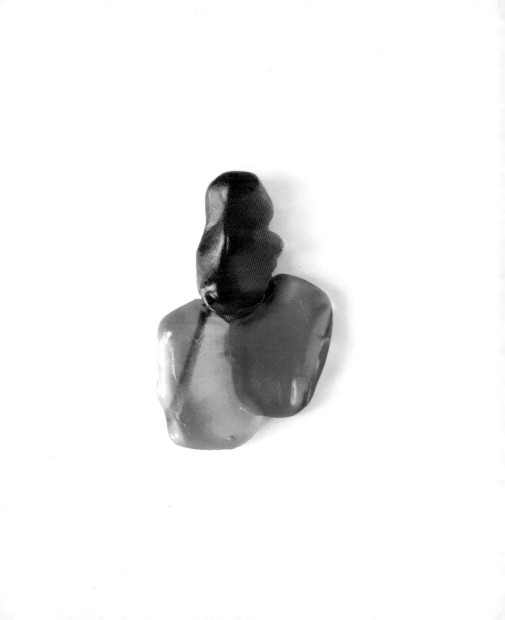

Polar Bear

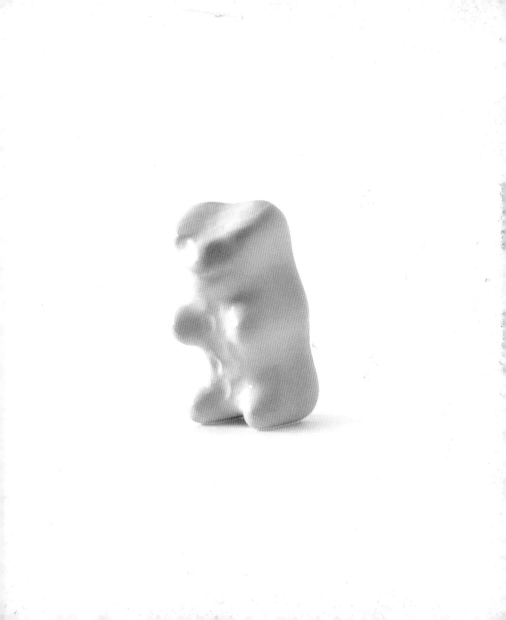

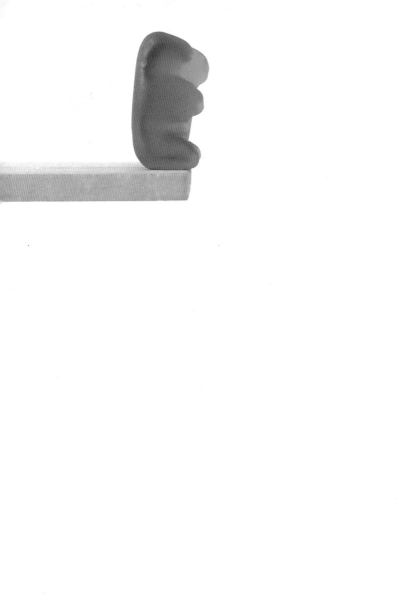

High Dive

Twins, In Utero

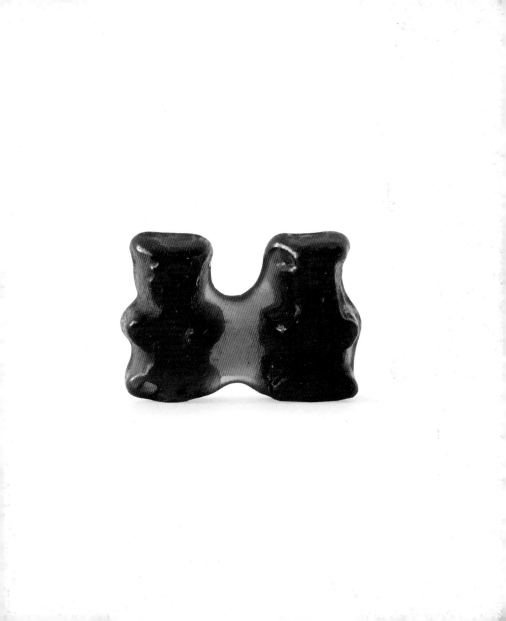

Van Gogh

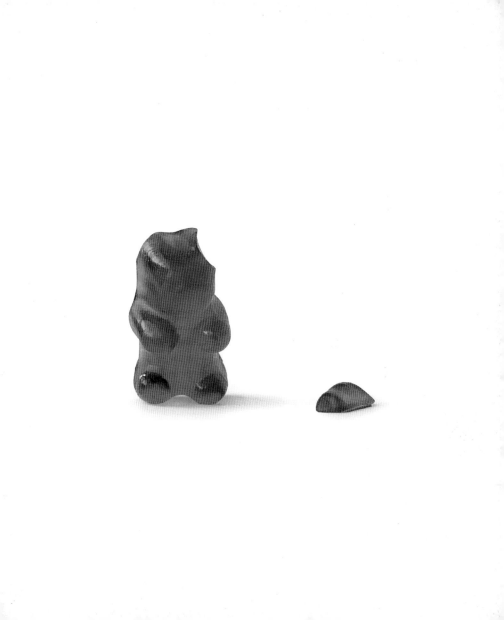

Cold Shoulder

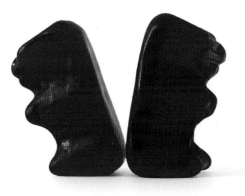

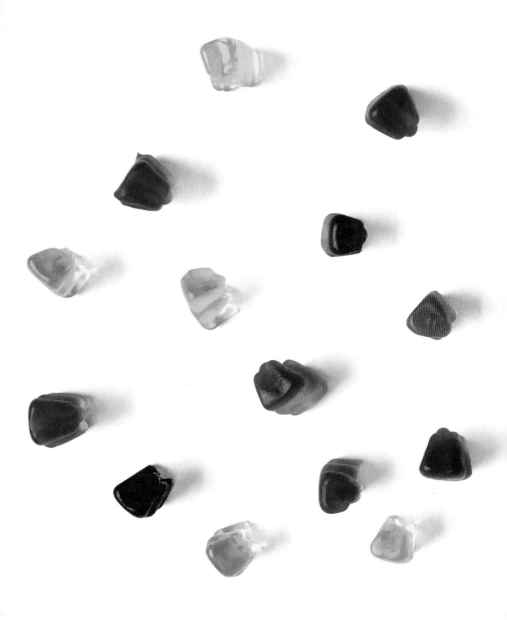

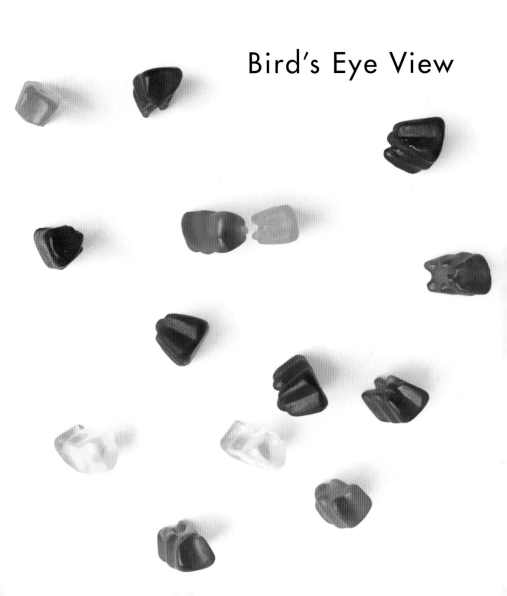

Bird's Eye View

Acupuncture

Tête-à-Tête

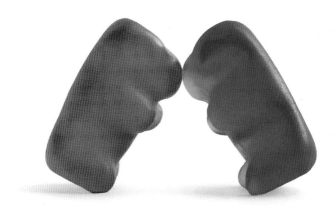

Orgy

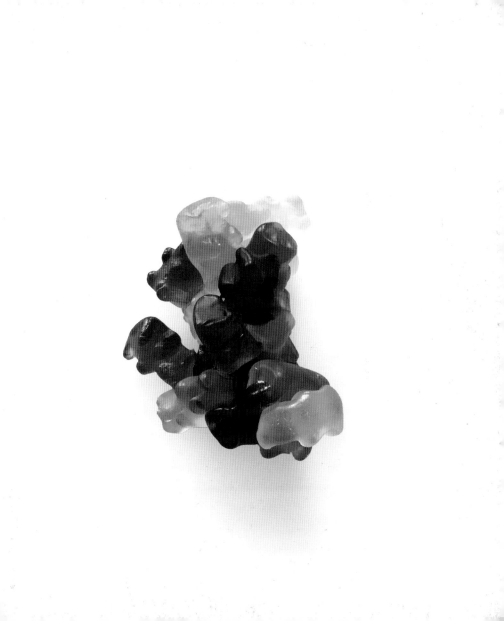

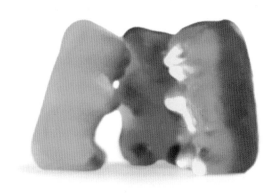

Loner

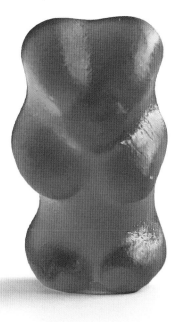

Selfies

Between the Sheets

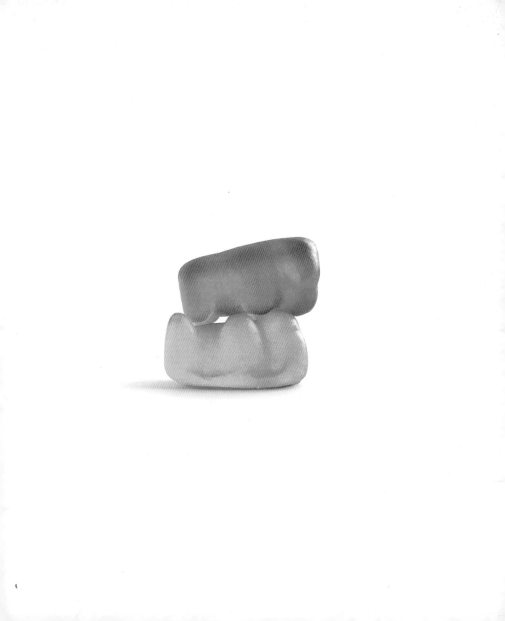

Mutants

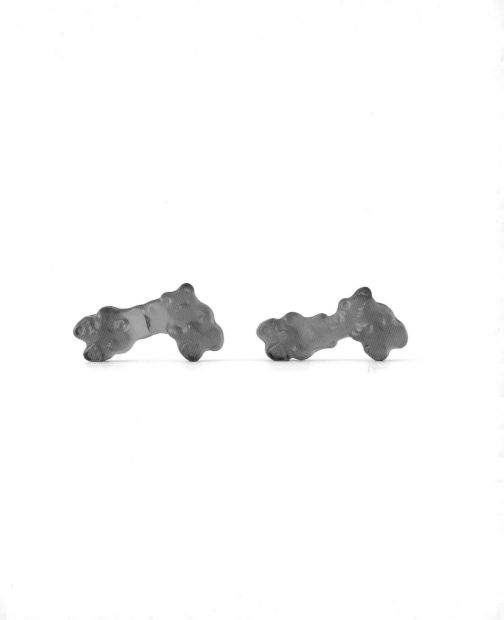

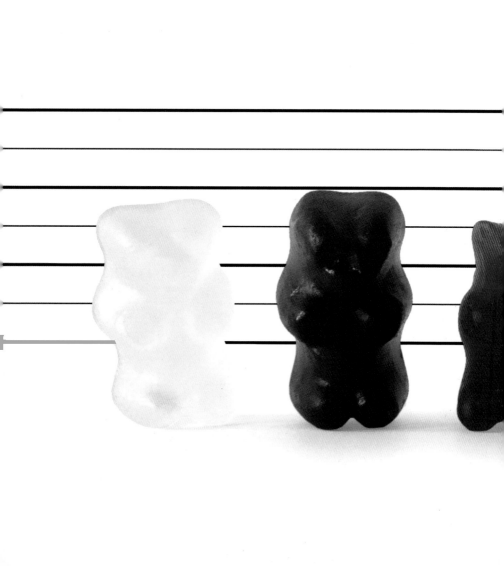

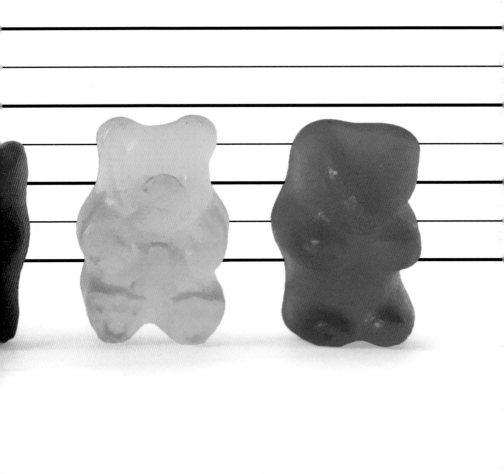

The Usual Suspects

Pawns

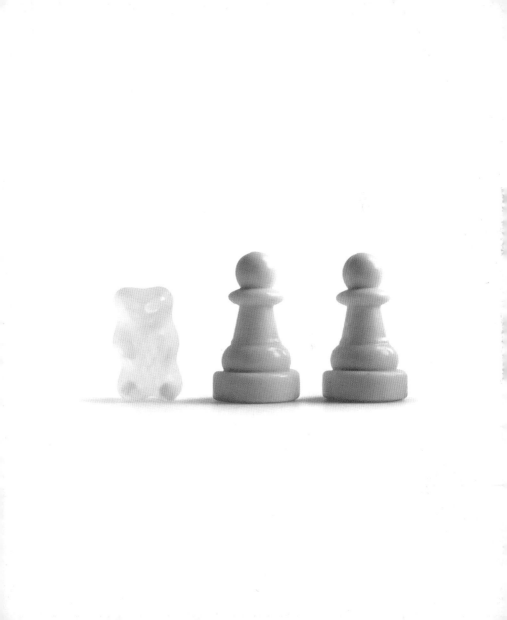

Jealousy

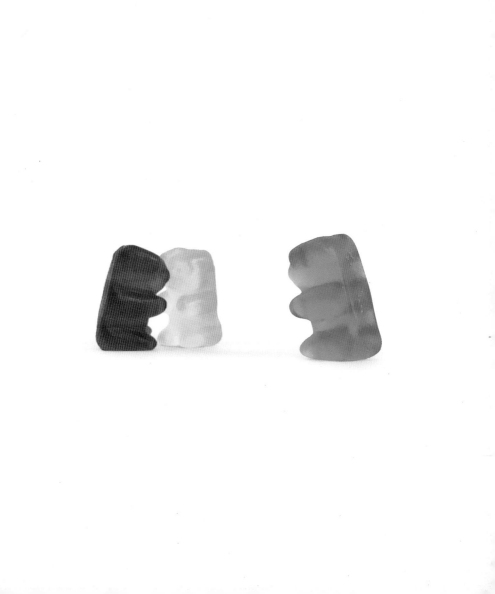

Ménage à Trois

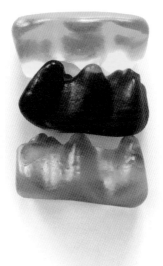

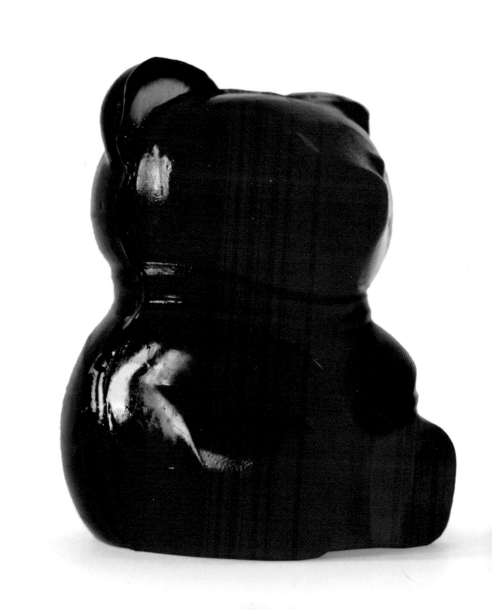

False Idol

Sisyphus

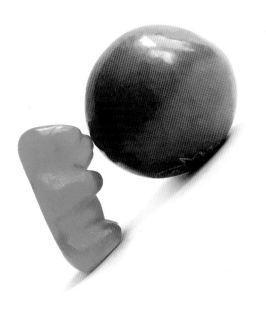

Bunkmates

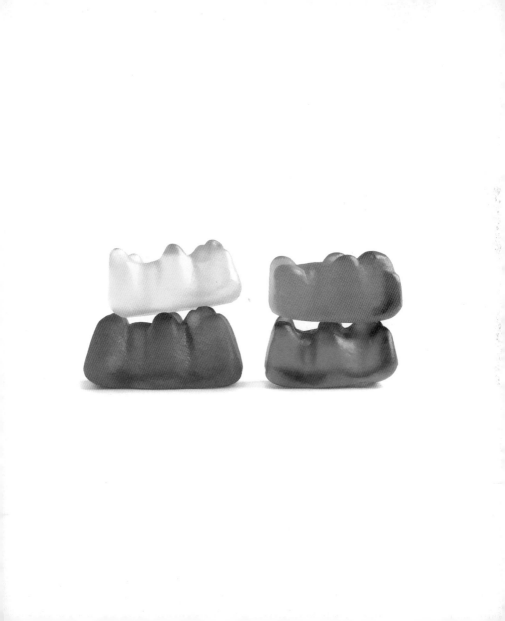

S, M, L

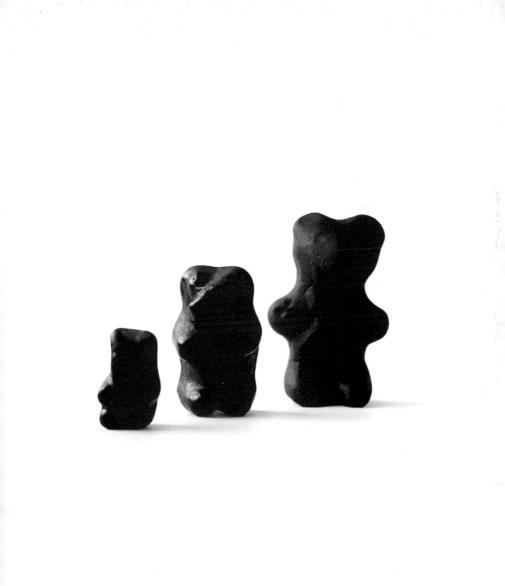

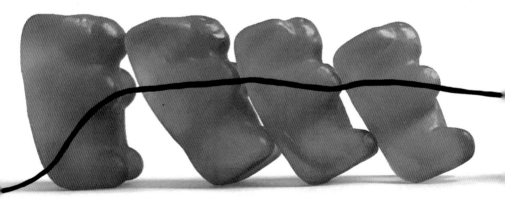

Tug of War

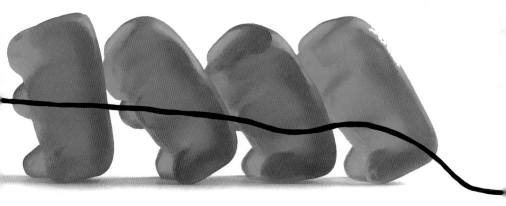

Snowball Fight

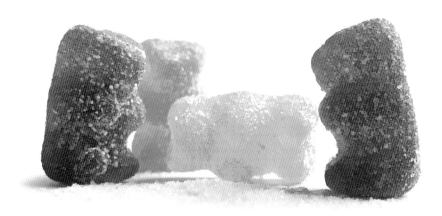

Mother and Child

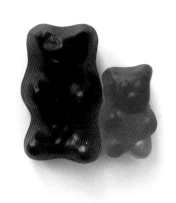

Father and Son

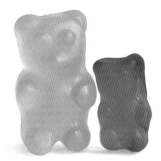

Order

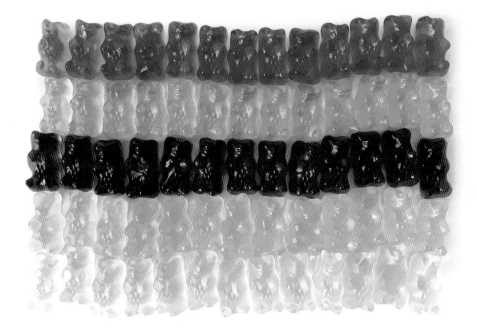

Chaos

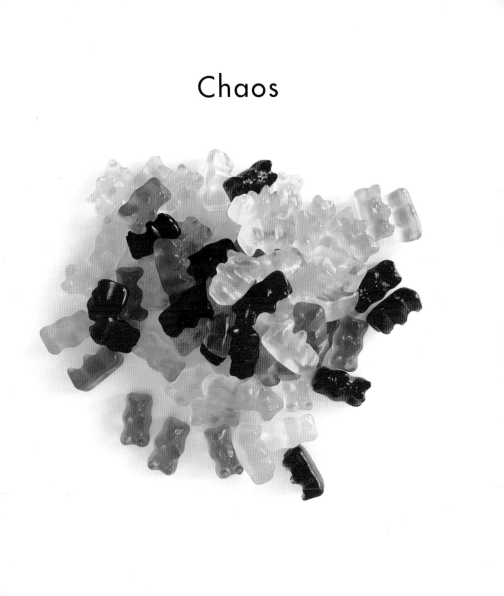

The Imposter

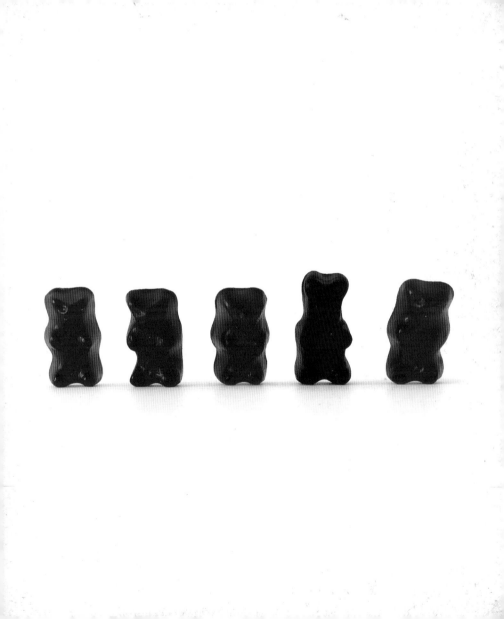

Totem Pole

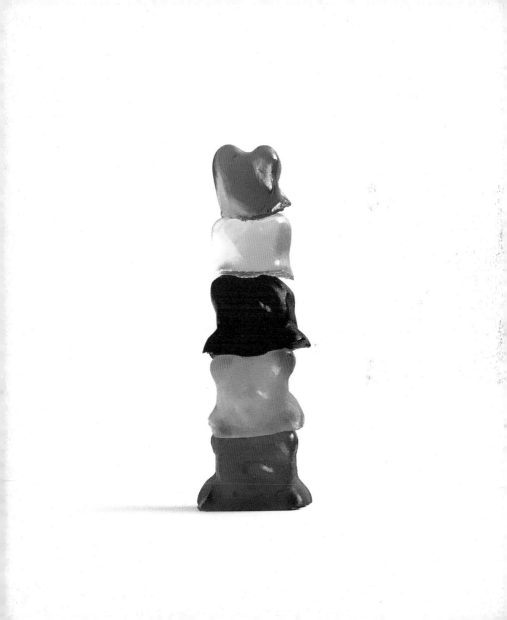

Feeling Blue

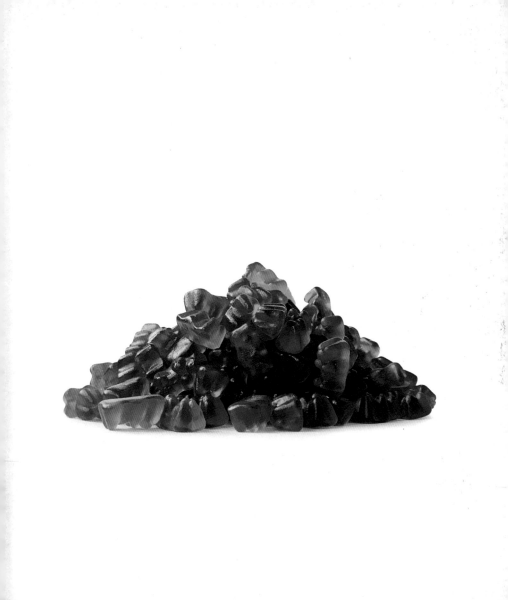

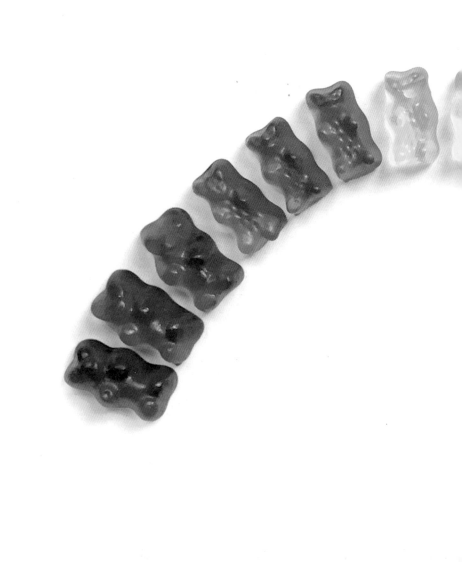

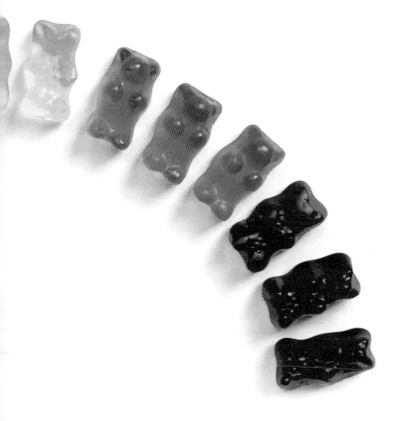

Love

Cowpoke

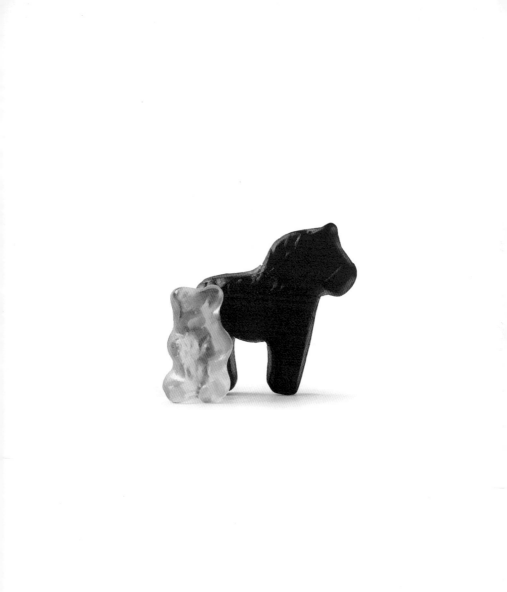

Sugar Mountain

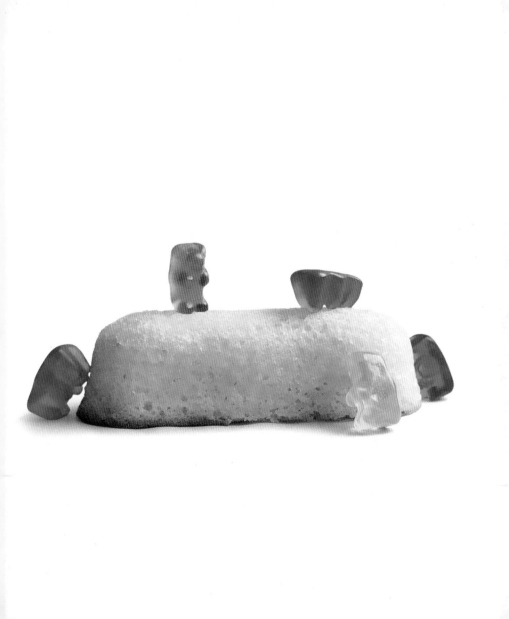

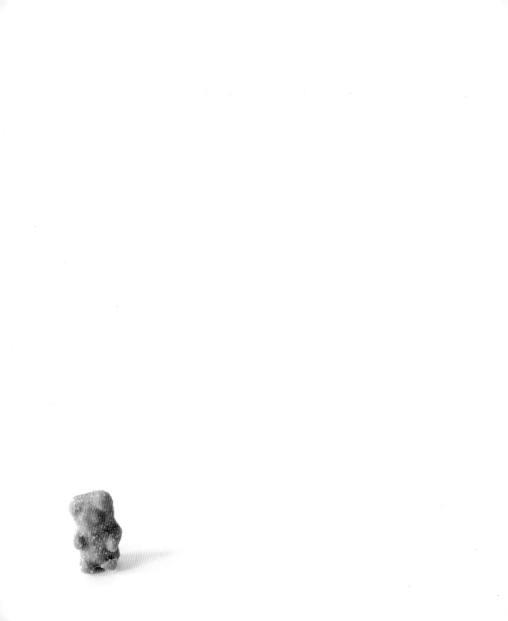

The Last Gummy Bear on Earth

Acknowledgments

Putting together a book of this magnitude was no small endeavor. It involved a team of dedicated researchers, editors, scientists, and psychologists working round the clock for nearly two years. It would take a lifetime to thank everyone who contributed individually, so let's focus on the most important:

My wife, Jen, who was okay with me buying (and eating) tons and tons of gummy bears, all in the name of art.

My Knock Knock editor, Erin, who loves gummy bears almost as much as I do, and who thought they would make a good subject for a book.

My best friend, Diana, who would kill me if I didn't give her a shout-out.

Lastly, to all the gummy bear eaters/lovers in the world— thank you.

About the Author

Dan Golden is a full-grown adult with a weakness for candy. He is also an artist, designer, and creative director whose work has appeared in numerous publications including, *The New York Times*, the *Los Angeles Times*, *Interior Design*, *Fast Company*, and *Elle*, among others. His designs have been produced by leading manufacturers such as CB2, Swarovski, and Stephanie Odegard. This is his first book (about gummy bears).

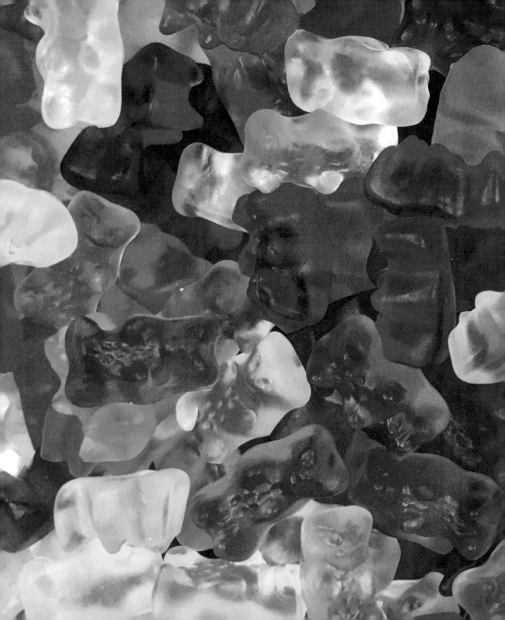